KLIMT

MARIA COSTANTINO

CHARTWELL
BOOKS, INC.

Published by
BOOK SALES, INC.
114 Northfield Avenue
Raritan Center
Edison, N.J. 08818

Produced by
Brompton Books Corp.
15 Sherwood Place
Greenwich, CT 06830

ISBN 0-7858-0211-8

Printed in China

LIST OF PLATES

GUSTAV KLIMT

1862-1918

Gustav Klimt was undoubtedly one of the most important Austrian painters of the *fin de siècle*. The second of seven children, Klimt was born in 1862 in Baumgarten, then a rural suburb of Vienna. In the last decades of the nineteenth century, in Klimt's youth, artistic teaching in Vienna was centered within two major institutions: the *Akademie der Bildenden Künste* [the Academy of Fine Arts], and the *Künstlerhausgenossenschaft* [the Society of the House of Artists], a private organization which possessed Vienna's only exhibition building and which was therefore able to exert great influence on both the public and official taste in art through its yearly exhibitions. In common with the academy, the *Künstlerhaus* was essentially conservative in its views and, reflecting their cautious continuity, the 1880s came retrospectively to be known as the "Makart Decade," after the then president of the *Künstlerhaus*, Hans Makart.

There was, however, a rival to the academy and its training, in the form of the Austrian Museum for Art and Industry. This had founded its own school of applied arts, the *Kunstgewerbeschule*, which had been modeled on the Schools of Art at South Kensington in London (now the Royal College of Art). In 1876, at the age of 14, Klimt was awarded a scholarship to the *Kunstgewerbeschule*, where he would remain for the next seven years, later being joined there by his brothers Ernst and Georg. For two years Klimt followed a pro-

gram of study in anatomy, history and technical and specialized drawing. An important figure in Klimt's early career was his painting professor, Ferdinand Laufberger, who allowed Klimt, his brother Ernst and fellow student Franz Matsch (1861-1942) to carry out the sgraffito ornamentation in the courtyard of Vienna's *Kunsthistorisches Museum* in 1879. In the same year all three students were involved in the preparations for a great masked parade around the *Ringstraße* as part of the celebrations organized by Hans Makart to mark the Imperial Silver Wedding. Now recognized as a master portrait painter, Makart is probably best remembered for his gigantic compositions featuring Viennese society belles in thinly disguised Renaissance pastiches. As president of the *Künstlerhaus*, Makart's taste dominated Viennese art, and his influence continued even past his death in 1884, for Klimt, regarded as Makart's "heir," carried out commissions based on Makart's original designs.

In 1880 the Klimt brothers and Matsch undertook the painting of four ceiling panels for the Palais Sturany (a Viennese town house) and, following an introduction by Laufberger to the theatrical architects Fellner and Helmer, they later produced a ceiling panel for the municipal theater in Karlsbad. Further commissions followed, in spite of the fact that Klimt was still technically a student. In 1881 the publisher Martin Gerlach commissioned designs for the publication *Allegories and*

Emblems, a collection of patterns and designs for which Klimt produced *The Four Seasons*. At the same time, the Klimt brothers and Matsch were also working on decorative paintings for the town of Reichenberg and for the Rumanian royal palace at Pelesch. The trio's style was increasingly in keeping with the ideals of Makart, revealing the influence of the old masters, in particular Titian, whose works Klimt copied from engravings.

By 1883 the Klimts and Matsch had set up their own studio in Vienna and were in great demand for their decorative work. In 1885 they were commissioned to paint murals for the Hermes Villa in Lainz, and also produced paintings for the Bucharest and Fiume municipal theaters. Their breakthrough came, however, in 1886, when the studio was awarded the commission to decorate the Karlsbad Theater. Gustav was responsible for painting two ceiling panels, while the three painters together produced the theater curtain, from a design originally conceived by Hans Makart. Despite this success, the highlight of Klimt's career as a historical painter would be the commission of ceiling and spandrel paintings for the two grand staircases of the *Burgtheater*, depicting the history of the theater. Klimt painted *The Chariot of Thespis*, *Shakespeare's Theater* and the *Altar of Dionysus* on the right-hand staircase; on the left the *Theater in Taormina* and the *Altar of Apollo*. Two years later, when the scheme was complete, Klimt was awarded the highest artistic honor for his work – the Gold Cross of Merit – by the Emperor Franz Josef.

Although Klimt was now fully accepted and acknowledged as the heir to the Makart tradition, this would be the last time that his work would satisfy Vienna's institutionalized tastes. Decorative symbolism was becoming increasingly central to his work, and Klimt was starting to turn away from the accepted contemporary academic conception of pictures by introducing soft-focus impressionistic techniques, and applying decorative materials like gold and silver leaf in an approach more closely related to the symbolist painters and to art nouveau ornamentation. This stylistic change is obvious in Klimt's next major commission: the decorations for the staircase of the *Kunsthistorisches Museum* in Vienna, a total scheme of 40 spandrel and intercolumnar paintings, 11 of which Klimt produced using the development of art from the time of ancient Egypt to the cinquecento as his theme. It is in these works that we see the first appearance of figures represented in strict frontality against a background of gold, and the first manifestation of the *femme fatale* figure, which would later be developed in drawings like *Tragedy* (1897), produced for the second series of Gerlach's *Allegories and Emblems*, and in paintings like *Judith I* (1901) and *Judith II (Salome)* (1909).

Despite the change in Klimt's artistic approach, the works for the museum were well received and led to the studio being commissioned to decorate the Great Hall of Vienna University in 1893. The recently built Great Hall had a central panel on the theme of the *Triumph of Light over Darkness*, along with one of the four side panels, *Theology*, painted by Matsch. The remaining three side panels, entitled *Philosophy* (1900), *Medicine* (1901) and *Jurisprudence* (1903) were produced by Klimt. But while the commissioning body had expected portraits of philosophers and great men of science in the historical manner, Klimt instead produced highly personal allegories and incorporated a number of female nudes. The huge canvases, unfortunately destroyed by fire toward the end of World War II, received such a hostile reaction that Klimt eventually bought back the commission in 1905. Apart from black-and-white photographs of the completed paintings, only the preparatory oil sketches and the detail of *Medicine*, depicting the figure of Hygeia, survive in color reproductions.

A number of factors may have contributed to Klimt's radical change of approach and style: it is possible that he may have felt some degree of resentment toward the official academy and its manner of painting after he was passed over by the Emperor for the post of Professor of Historical Painting there in 1893. Furthermore, his brother Ernst had married Helen Flöge, one of three daughters of a wealthy Viennese family which ran a popular fashion house. Through his brother's marriage Klimt gained entry into Viennese bourgeois cultural society, and, in addition, another Flöge daughter, Emilie, whose portrait he painted in 1902, became Klimt's lifelong companion. It is in this portrait that the distinguishing characteristics of Klimt's later portraiture – the creation of abstract patterns while retaining a naturalistic rendering for the faces and hands of the sitters – first emerges.

Through his friend and colleague, the painter Carl Moll, Klimt was introduced to wealthy Viennese families who had acquired not only riches, but also a more progressive taste in art. Klimt undertook numerous portrait commissions for these families, including that of

Serena Lederer (1899), the wife of August Lederer, who was the main financier and co-founder of the *Wiener Werkstätte* [the Viennese Workshop]; the Lederer's daughter, in the *Portrait of Baroness Elisabeth Bachofen-Echt* (c.1914); the portrait of Margaret Stonborough-Wittgenstein (1905), the daughter of a steel baron and great patron of the arts, who not only supported the composers Brahms and Mahler, but also helped to finance the construction of the Secession building; the portrait of Mäda Primavesi (c.1912), the daughter of the financial backer of the *Werkstätte* following Fritz Wärndorfer's (its original patron) emigration to America; and the portrait of Friederike Maria Beer (1916), the daughter of a wealthy nightclub owner and patroness of the *Werkstätte*.

Possibly the most important influence on Klimt's work, however, was the foundation in 1897 of the Vienna Secession. Led by Klimt, the Secession was set up by some of the younger members of the *Genossenschaft Bildender Künstler* [the Association of Visual Artists] in rebellion against the teachings of their seniors, and also as an attempt to give more artists the opportunity to exhibit their works. The Secessionists planned to show not only the works of Austrian artists, but also those of their contemporaries abroad, since they considered the Viennese to be insular and ignorant of artistic developments in France, England and the Low Countries; indeed, few Viennese had ever heard of Gauguin, Manet or van Gogh.

The first exhibition of the Secession opened on 26 March 1898 at the premises of the Vienna Horticultural Society, for which Klimt designed the exhibition's accompanying poster, which showed Theseus slaying the Minotaur. The censors objected to the poster, and Klimt was forced to add the device of a tree, thus obscuring Theseus's offending genitalia. Theseus's death blow to the Minotaur was designed to symbolize the battle between the Secession and the official academy, while the figure of Athena, long recognized as the symbolic protector of artistic groups, looks on. In a square oil painting done in the same year, Klimt again portrayed the warrior goddess of wisdom in *Pallas Athene* (1898). Notable for its exquisite metal frame designed by the artist and made by his brother Georg, *Pallas Athene* is a good example of Klimt's habit of repeatedly reworking a particular theme or "leitmotif"; the first time the figure of Athena appeared in his work was in a spandrel painting for the *Kunsthistorisches Museum*. Other leit-

motifs which reappear throughout Klimt's career are those of the lyre-playing girl who first appears in *Music I* (1895) (which is also one of Klimt's earliest works to make significant use of the color gold), in a color lithograph, *Music*, published in the Secession's magazine *Ver Sacrum IV* ["Sacred Spring"] in 1901, and in the figure of "Poetry" in the *Beethoven Frieze* of 1902; the sunflower motif, as seen in *Cottage Garden with Sunflowers* (c.1905-06) and *The Sunflower* (1906-07); symbolic representations of fertility in *Hope I* (1903) and *Hope II* (1907-08); and architectural motifs in the three versions of the paintings depicting the Schloss Kammer from 1908, 1909 and 1910.

The first Secession exhibition, which included works by Böcklin, Rodin, Carrière, Whistler, Mucha, Puvis de Chavannes and Walter Crane, as well as by the Secession's Austrian members, proved a success. In the first instance it provided sufficient impetus for plans to be made for an exhibition building of the Secession's own, to be designed by Josef Olbrich; and secondly, because the contact with a wider range of artists outside Austria influenced Klimt's own work. At the second Secession exhibition in November 1898, Klimt showed his *Pallas Athene* and the *Portrait of Sonja Knips* (1898), the former painting demonstrating the influence of art nouveau (or *Jugendstil*, as it was called in Austria and Germany), while the latter portrait appears gently impressionistic. The *Portrait of Sonja Knips* is also the first of Klimt's large, square-format portraits of females, and while this painting may at first sight bear little resemblance to the later portraits, where increasingly the sitter's clothes are translated into flat decorative patterns, nevertheless, in the portraits of *Adèle Bloch-Bauer I* (1907) and *Fritza Riedler* (1906), the similar, off-center triangular structure of Sonja Knip's pose reappears, as well as a certain tension expressed through the clasped hands. This device of tensed hands can also be seen in *Judith II (Salome)* (1909) and in *The Kiss* (1907-09) — Klimt's most popular painting, and one in which we see the culmination of his "mosaic" manner, using mixed media in the utmost decorative splendor. Here the stylization of clothes, which can be observed in the earlier portraits, reaches its peak in pure surface pattern. Furthermore, *The Kiss* represents Klimt's most elaborate reworking of the theme of the embrace, first seen in the painting *Love* (1895), then in the *Beethoven Frieze* (1902), and also in the figures of *Fulfillment* from the *Stoclet Frieze* (c.1905-09).

Subsequent Secession exhibitions were also important to Klimt's work: in 1899 he showed two major works – *Schubert at the Piano* (1899), and *Nuda Veritas* (1899). Painted to accompany two *sopraporte* representations of music produced for the music room of Nikolaus Dumba's villa, Klimt's painting of the Viennese composer Franz Peter Schubert displays a considerable debt to the French Post-Impressionists in his use of a loose pointillist technique. *Nuda Veritas* was bought by Hermann Bahr, a literary adviser to *Ver Sacrum* and author of numerous essays in which he declared that artists should be freed from the strictures of creating mere reflections of reality. The problems facing those artists who undertook this new approach are summed up in *Nuda Veritas*, which bears the quotation from Schiller: "If you cannot please all men by your actions and by your art, then please a few. To please everyone is bad."

The sixth Secession exhibition in January 1900 was devoted entirely to Japanese art. While the exhibition itself did not meet with much enthusiasm from the Viennese public as a whole, it was valuable to Klimt, for it awakened in him an interest in Eastern art which he then began to collect. Soon he possessed a multitude of paintings, ceramics, sculptures and textiles (Klimt's interest in textiles was also shared by Emilie Flöge, who had her own large collection of ethnic textiles, whose motifs she incorporated into the designs for her fashion salon, the *Casa Piccolo*). Many of these objects would now appear in the background of Klimt's paintings of society women, such as a design taken from a Korean vase in his *Portrait of Friederike Maria Beer* (1916); Chinese figures in the *Portraits of Adèle Bloch-Bauer II* (1912), *Elisabeth Bachofen-Echt* (c.1914) and in *The Dancer* (c.1916-18), while exotic birds in the Japanese manner form the background in *The Friends* (1916-17).

The fourteenth Secession exhibition in April 1902 was dramatically different from earlier ones, for this time the exhibition centered on the single monumental sculpture of Beethoven by Max Klinger. Klimt's contribution to this exhibition was the *Beethoven Frieze*, a cycle of paintings in three episodes, painted on plaster in casein colors (pigments bound together with an emulsion of protein, water and ammonium carbonate) and decorated with gold and semiprecious stones. On the first, long wall Klimt described the theme of "Yearning for Happiness," which was personified by three figures, collectively called "The Sufferings of Weak Humanity,"

who beseech the knight in armor, "The Well-Armed Strong One." On the second, narrower wall were depicted the "Hostile Powers," in the form of the giant Typhon and his three Gorgon daughters, attended by the figures of Sickness, Mania, Death, Debauchery, Unchastity, Excess and Corroding Grief. On the third, long wall, "Yearning for Happiness" finds solace in "Poetry" (a reworking of the figure depicted in *Music I*), while the Choir of Heavenly Angels surrounds an embracing couple representing "The Kiss of the Whole World." It is perhaps possible to interpret the *Beethoven Frieze*, particularly the last panel, as the visual equivalent of the emotions and ideals expressed by Beethoven in the final movement of his Ninth Symphony, in which he sets to music Schiller's poem *The Ode to Joy*, and from which Klimt borrowed the phrase "*Diesen Kuss der ganzen Welt.*"

In spring 1903, Klimt visited Italy and made a discovery there which would further influence his work: Byzantine art. The Byzantine mosaics which he saw at San Vitale, depicting the Emperor Justinian and the Empress Theodora, each with their own retinue, combine the characteristics of early Christian art with a tendency toward realism. The impact which these monumental mosaics made on Klimt is reflected not only in *Jurisprudence* (1903), designed for the Great Hall of the university, and in his later paintings *The Kiss* (1907-09), *Fritza Riedler* (1906) and *Adèle Bloch-Bauer I* (1907), but also in Klimt's magnum opus and his only true mosaic, the *Stoclet Frieze* (1905-09).

The *Stoclet Frieze* was designed for the dining room of the Palais Stoclet, the Viennese home of the Belgian financier Adolphe Stoclet and his wife Suzanne, and was to be the centerpiece of a magnificent mansion housing their art collection. The frieze, executed by Leopold Forstner (1878-1936) to Klimt's design, was designed to be made in gold and silver, with enamel, coral and semiprecious stones set against white marble walls. On each of the two long walls were seven panels depicting the "Tree of Life." The panels on these two walls were identical, except for the second panels: on one is the figure of a woman, symbolizing "Expectation," while on the opposite wall there are the figures of an embracing couple, who symbolize "Fulfillment."

The climax of Klimt's "mosaic" style, *The Kiss* (1907-09), in its combination of oils and golden decoration, is a work of magnificent splendor. The stylization of the clothing, first apparent in the *Portrait of Emilie Flöge*

(1902), later in the *Portrait of Adèle Bloch-Bauer I* (1907), and also in the *Stoclet Frieze* (1905-09), is here taken to its extreme.

While it is the images of women which dominate Klimt's *oeuvre*, both in his portraits and in his allegorical paintings, it is also possible to call to mind three portraits of male sitters: *Schubert at the Piano* (1899), *Hofburg Actor Josef Lewinsky as Carlos in Clavigo* (1895), and the magnificent *Portrait of the Pianist and Piano Teacher Josef Pembauer* (1890), which is remarkable not only for its wooden frame (which is believed to have been designed by Klimt), but also for the photographic realism employed. In addition to these portraits, the area around the Attersee, particularly the Schloss Kammer, would provide Klimt with the subject matter for many landscape paintings. For 10 years Klimt and the Flöge sisters traveled to the Attersee each summer – the only exceptions being trips to Lake Garda in Italy in 1913 (where he painted *Church at Cassone*), and Mayrhofen in Austria in 1917 – and while some of Klimt's paintings are indebted to the French Post-Impressionists, some of his views, like *Avenue in the Park of the Schloss Kammer* (1912), with their thicker colors and rhythmic forms, betray the influence of van Gogh.

By habit a studio painter, in his landscape paintings Klimt nevertheless showed his mastery of plein-air painting and, like Monet, he would often paint from his boat out on the lake, thus ensuring no interruptions. As an artist who made numerous studies and drawings for his portraits and allegorical compositions, it seems unusual that Klimt should paint these landscapes without preliminary studies. It is possible that his notebooks, which he always carried with him (one of which Sonja Knips holds in her hand in Klimt's portrait of her) could have provided us with greater insight into these works and their motivation, but they have disappeared, possibly having been destroyed.

As Europe embarked upon World War I, portraiture occupied a great deal of Klimt's time and energy. In 1915 he temporarily abandoned strong colors and produced two portraits in muted gray and green tones: those of Barbara Flöge (Emilie's mother) and Charlotte Pulitzer (Serena Lederer's mother). Yet another important change can be seen from the beginning of 1917:

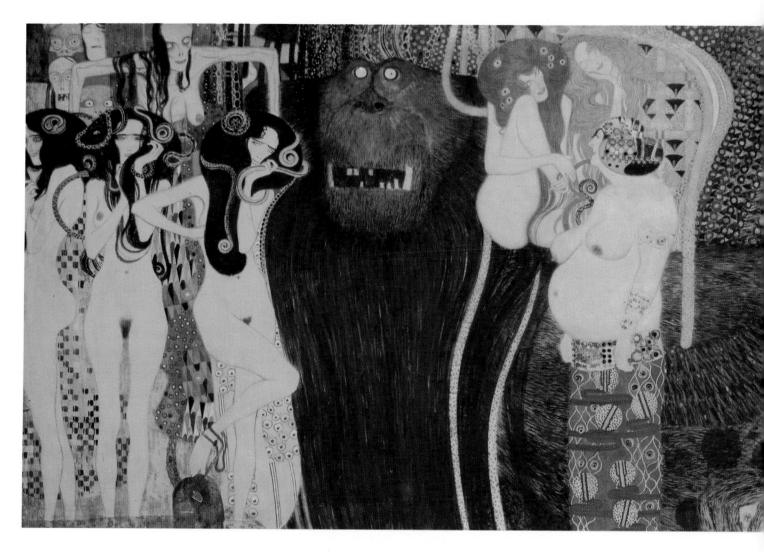

although Klimt's emphasis on pattern, decoration and strong colors is still in evidence, there is now an increasing concern with more geometrical compositions and forms. In *Baby* (1917-18) (also called *The Cradle*), Klimt used a triangular shape as the basis for the composition. This heightened interest in the problems and nature of structure is an indication of his contact with the young painter Egon Schiele (1890-1918), whose own work displayed an exaggerated geometry. While "Klimtian" elements remain in paintings like *The Bride* (1917-18), for example, the central sleeping figure with her head turned aside, the intertwined group of figures on the left, and the rear view of the nude female torso, all of which are familiar from earlier works such as *Goldfish* (1901-02), *The Virgin* (1913) and *Death and Life* (1916), now the abstract elements of the compositions are preferred to the representational and spatial.

The importance which Klimt was now giving to these abstract compositional elements, and the new direction he was taking in his art, were both cut tragically short, leaving several canvases standing unfinished in his studio. Following a Christmas trip to Rumania in January 1918 he suffered a stroke which was aggravated by the influenza epidemic ravaging Europe. On 6 February 1918, Gustav Klimt died, and was buried in the Hietzing Cemetery in Vienna. Egon Schiele suggested preserving Klimt's studio for posterity, but the acute shortage of living accommodation at the end of World War I made it necessary to convert the property into apartments. Sadly, with the breakup of the studio and the subsequent distribution of his works, numerous documents went astray, documents which no doubt would have given us a greater understanding of Klimt's workings, and particularly of his later paintings.

HOSTILE FORCES, 1902
Detail from the *Beethoven Frieze*
Casein paint on plaster, 7 ft 2⅛ × 20 ft 10½ inches
(220 × 636 cm)
Österreichische Galerie, Vienna

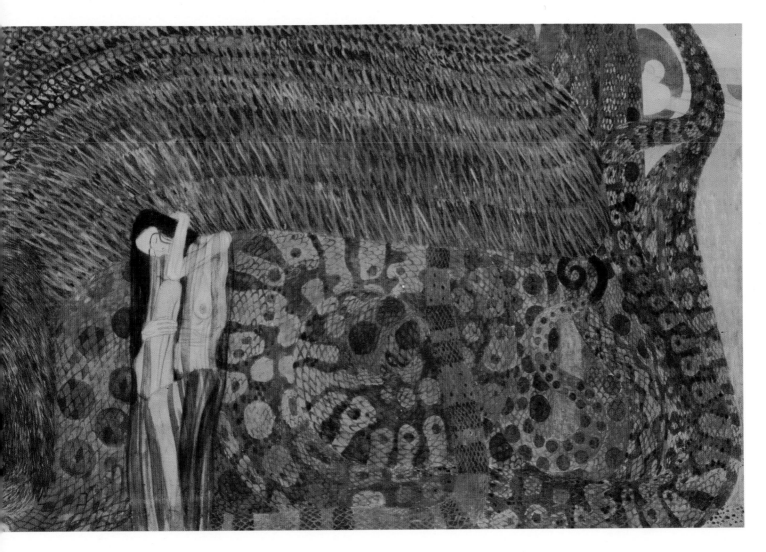

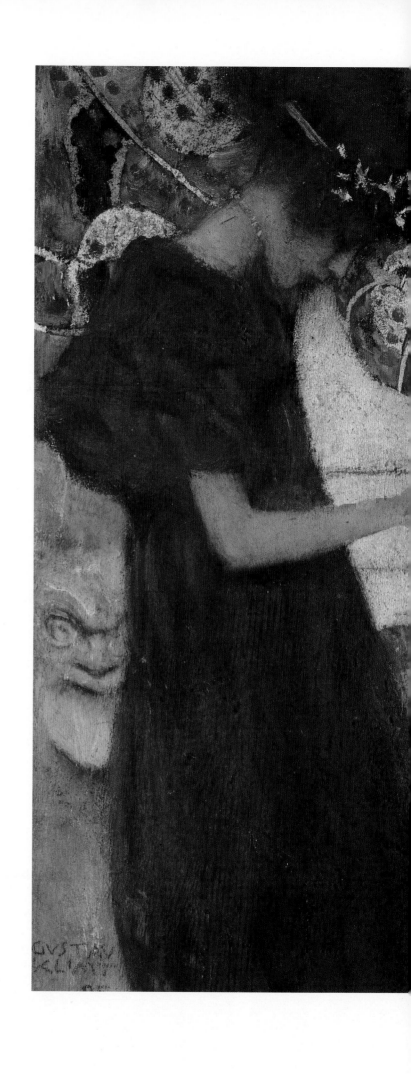

Music I, 1895
Oil on canvas, 14½ × 17½ inches (37 × 44.5 cm)
Bayerische Staatsgemäldesammlungen,
Neue Pinakothek, Munich

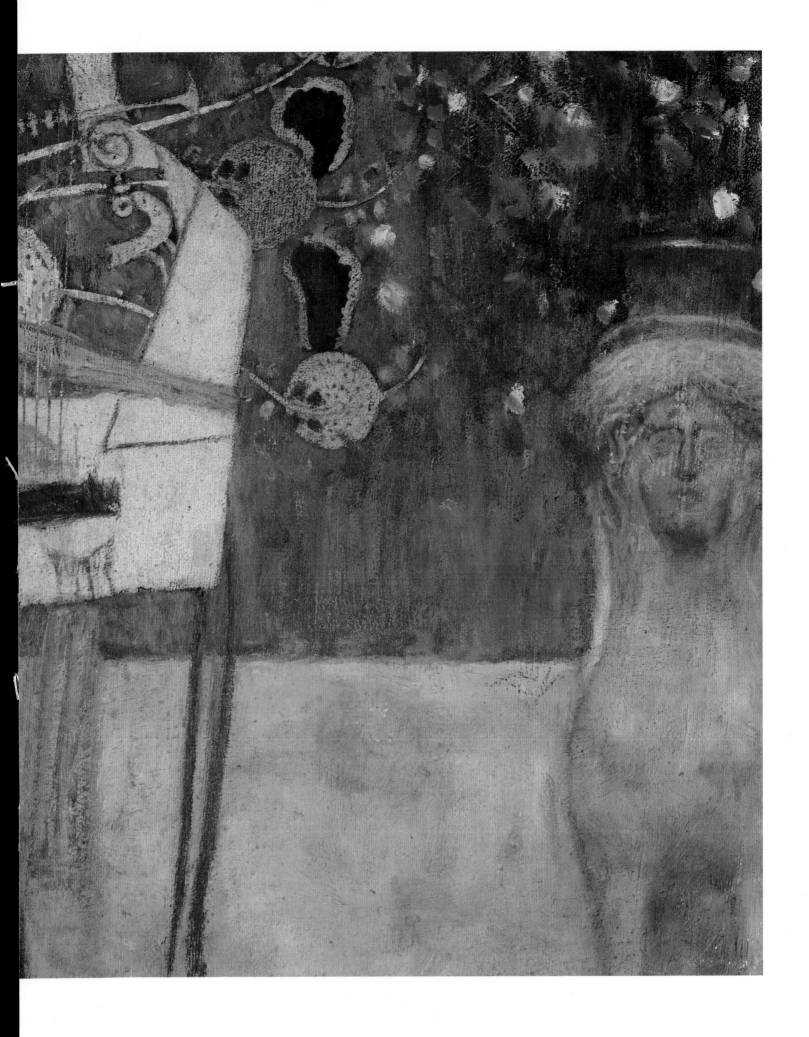

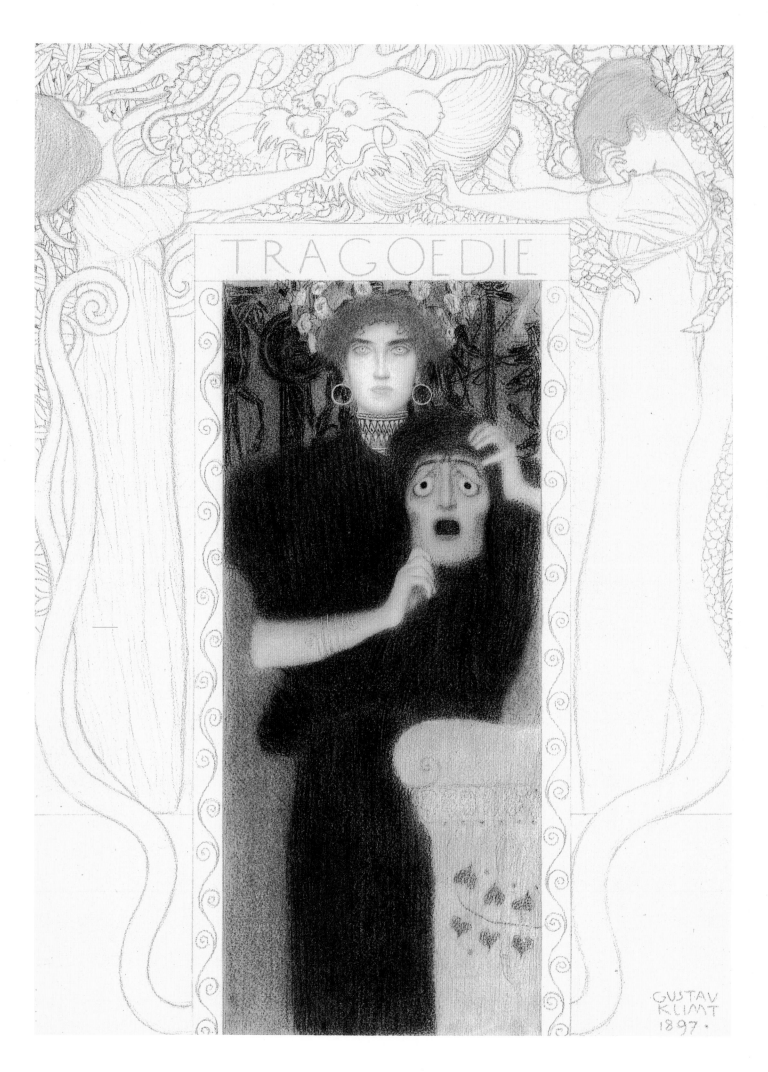

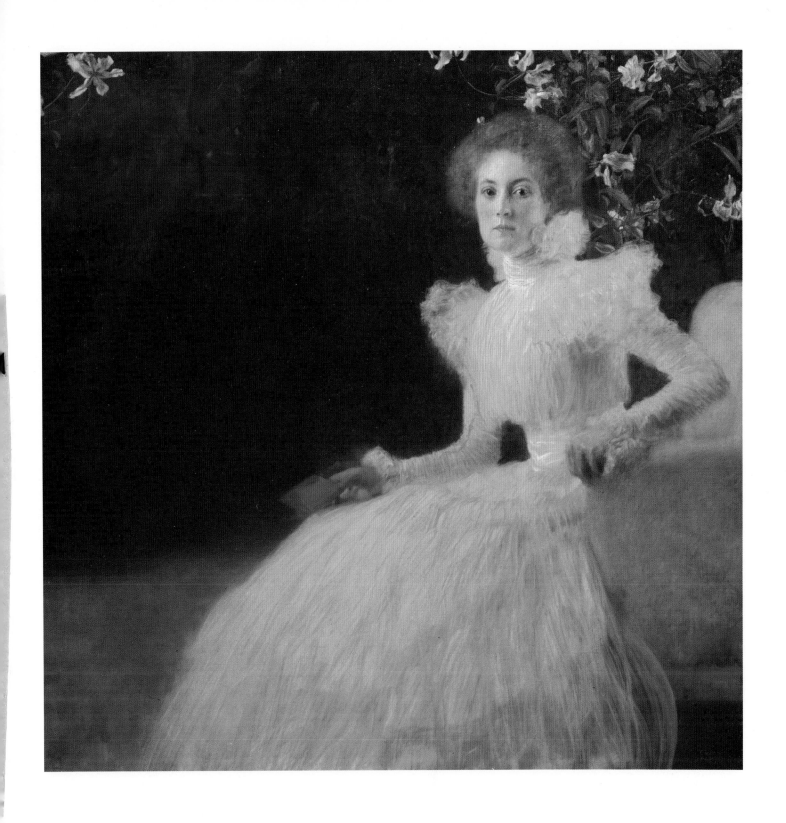

Left:
TRAGEDY, 1897
Black chalk, pencil and wash with white and gold
highlights on paper, 16½ × 12½ inches (41.9 × 30.8 cm)
Historisches Museum der Stadt Wien, Vienna

Above:
PORTRAIT OF SONJA KNIPS, 1898
Oil on canvas, 57 × 57 inches (145 × 145 cm)
Österreichische Galerie, Vienna

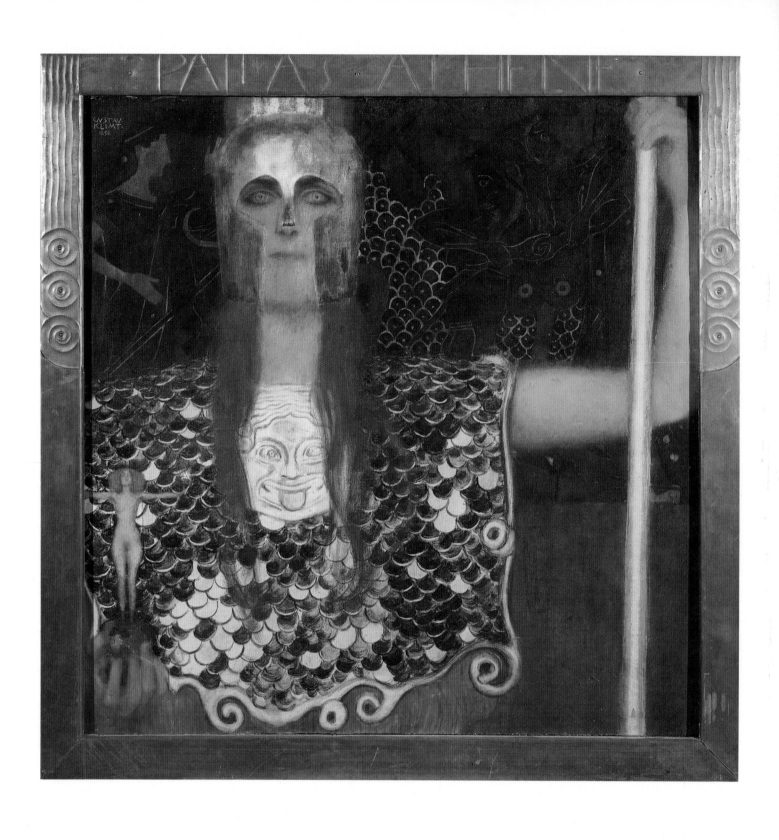

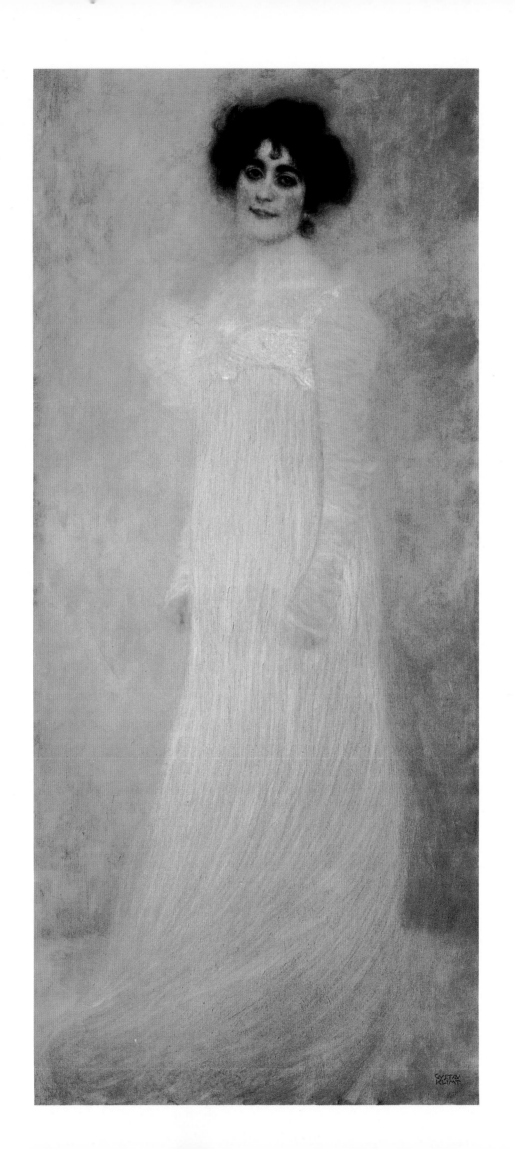

15

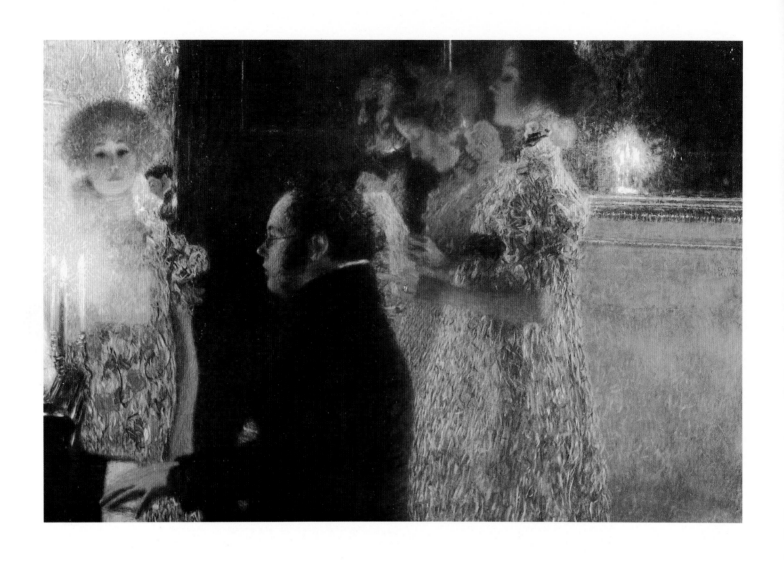

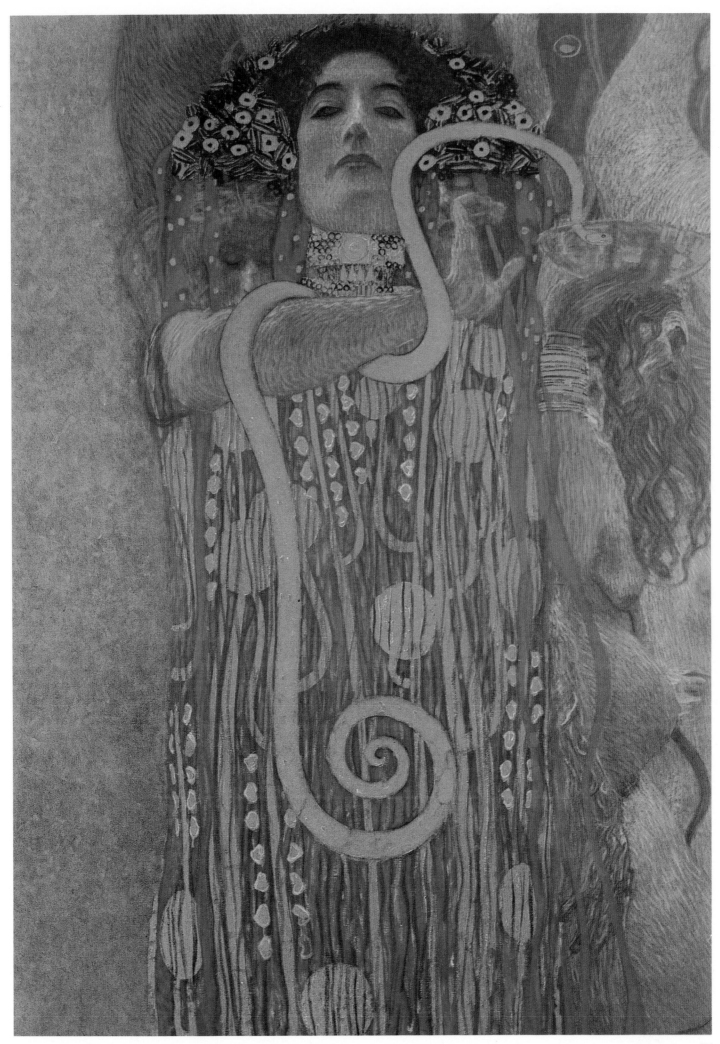

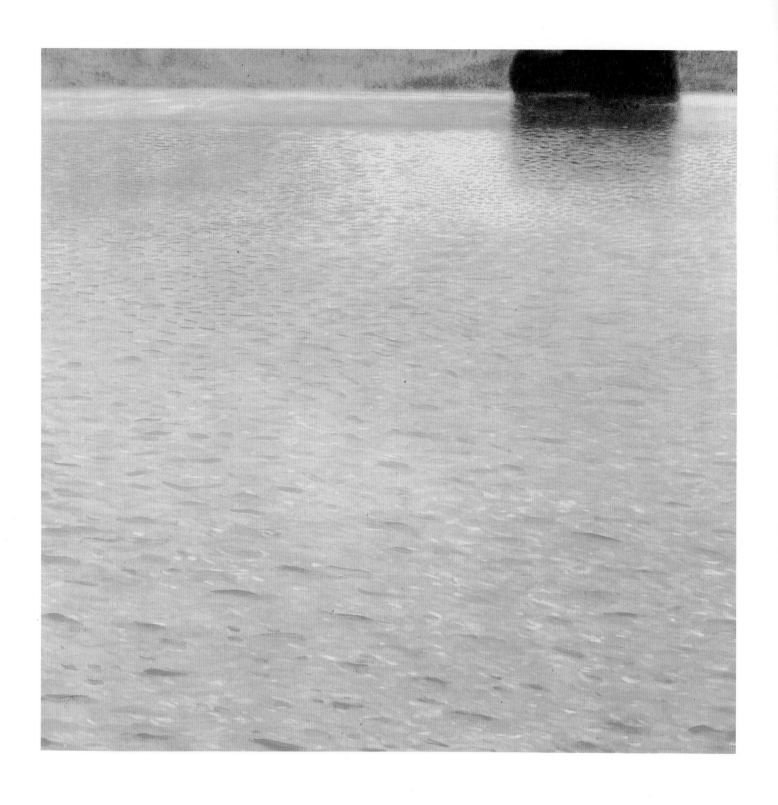

ISLAND IN THE ATTERSEE, *c.*1901
Oil on canvas, 39⅜ × 39⅜ inches (100 × 100 cm)
Private Collection,
Courtesy Galerie St. Etienne, New York

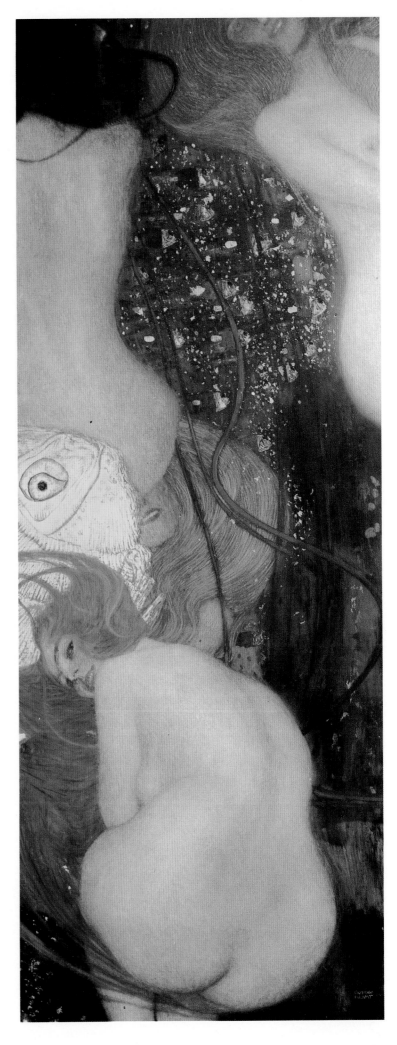

GOLDFISH, 1901-02
Oil on canvas, 59 × 18⅛ inches (150 × 46 cm)
Private Collection, Solothurn,
Courtesy Galerie Welz, Salzburg

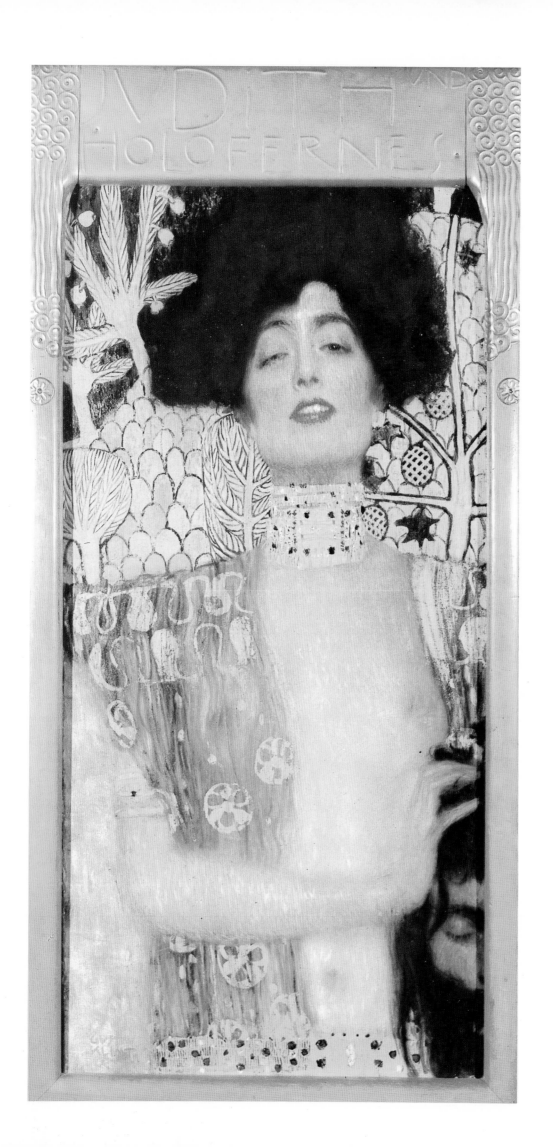

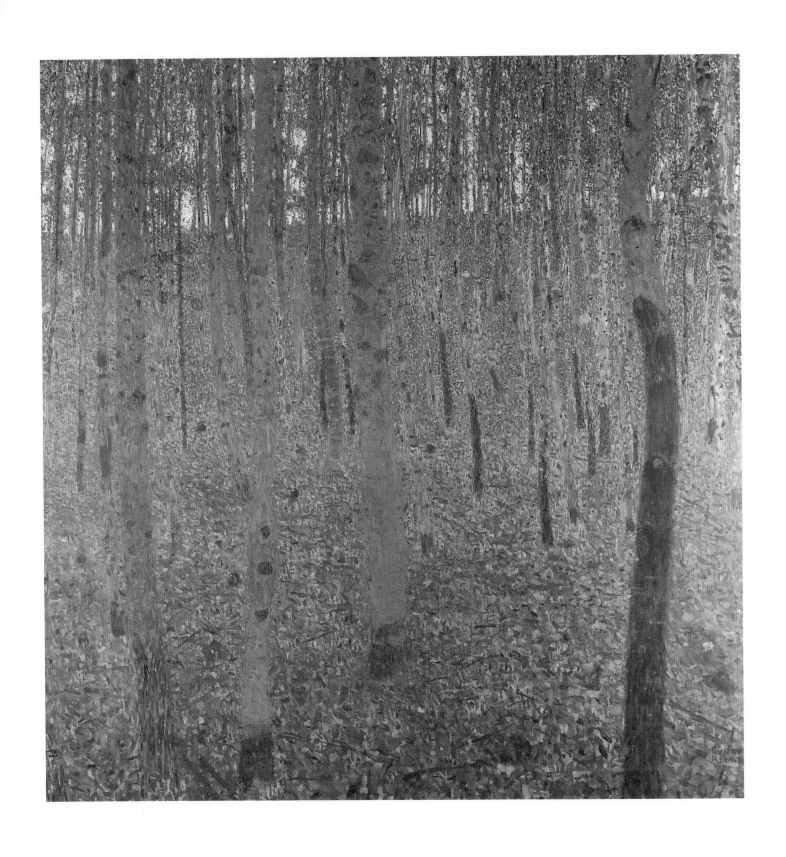

Left:
JUDITH I, 1901
Oil on canvas, 33 × 16½ inches (84 × 42 cm)
Österreichische Galerie, Vienna

Above:
BEECH WOOD I, *c.*1902
Oil on canvas, 39⅜ × 39⅜ inches (100 × 100 cm)
Moderne Galerie, Dresden

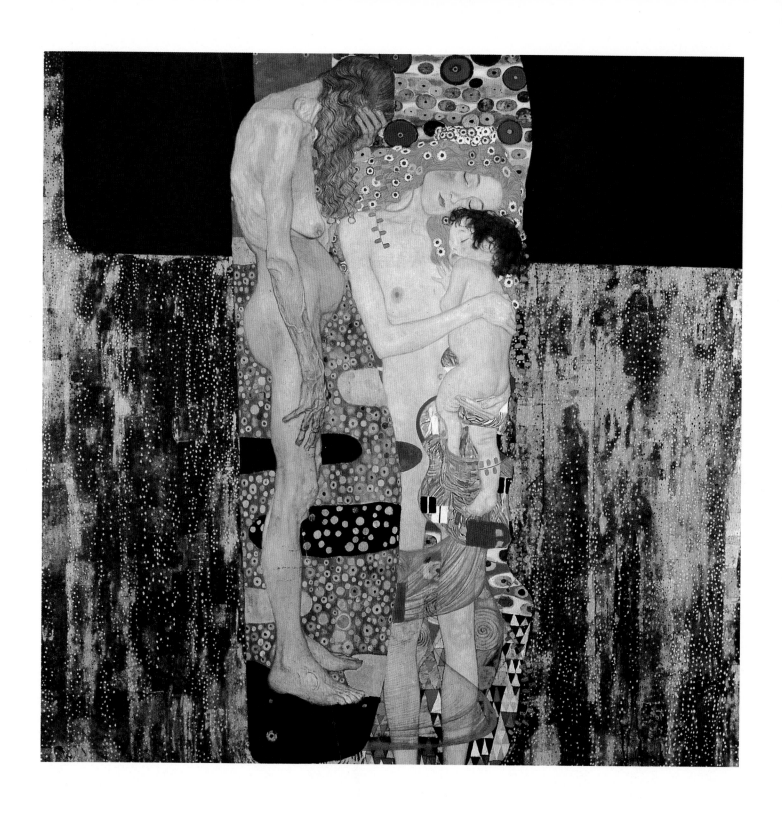

Right:
FULFILLMENT, *c.*1905-09
Working drawing for the *Stoclet Frieze*
Tempura, watercolor, gold paint, silver bronze, chalk,
pencil, white bodycolor, gold and silver leaf on paper,
76 × 45¼ inches (193 × 115 cm)
Österreichisches Museum für Angewandte Kunst, Vienna

Above:
THE THREE AGES OF WOMAN, 1905
Oil on canvas, 70⅞ × 70⅞ inches (180 × 180 cm)
Galleria Nazionale d'Arte Moderna, Rome

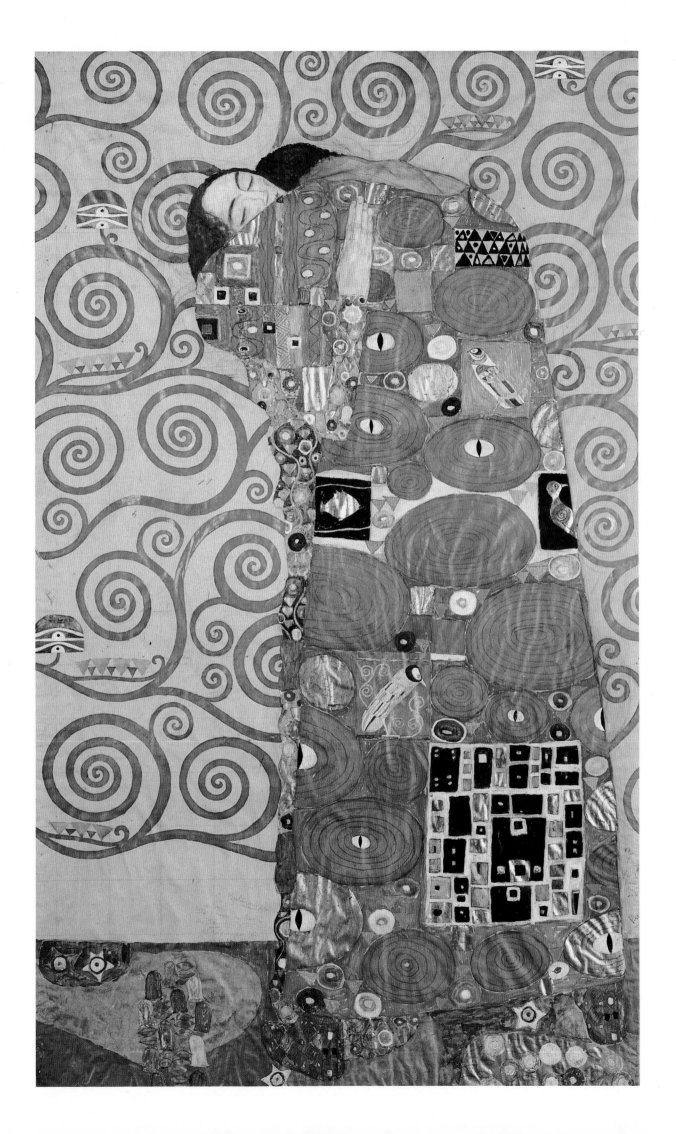

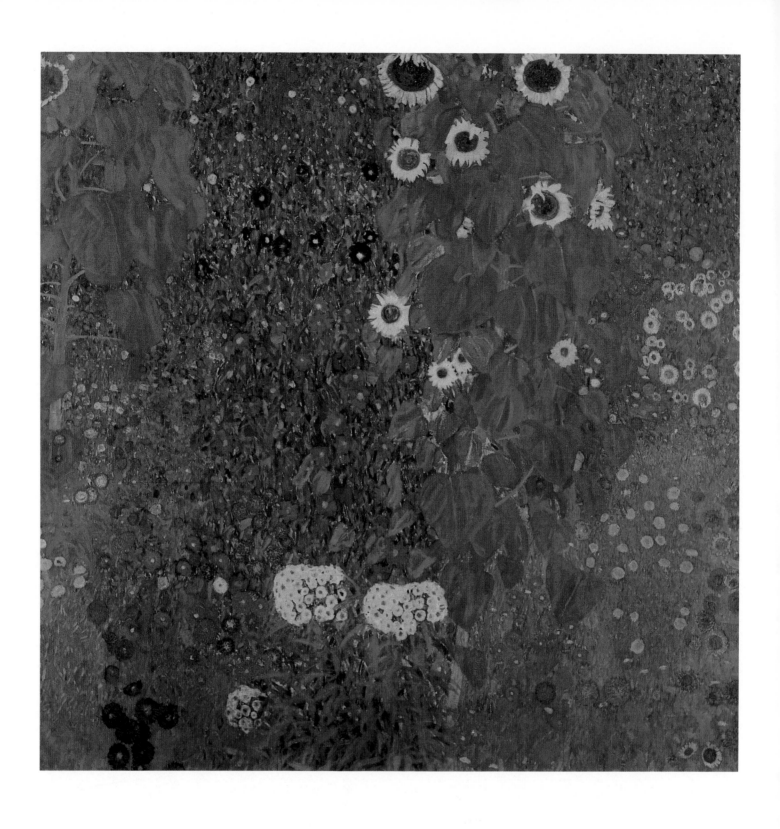

Above:
COTTAGE GARDEN WITH SUNFLOWERS, *c.*1905-06
Oil on canvas, 43⅓ × 43⅓ inches (110 × 110 cm)
Österreichische Galerie, Vienna

Right:
PORTRAIT OF MARGARET STONBOROUGH-WITTGENSTEIN,
1905
Oil on canvas, 70⅞ × 35 inches (180 × 90 cm)
Bayerische Staatsgemäldesammlungen,
Neue Pinakothek, Munich

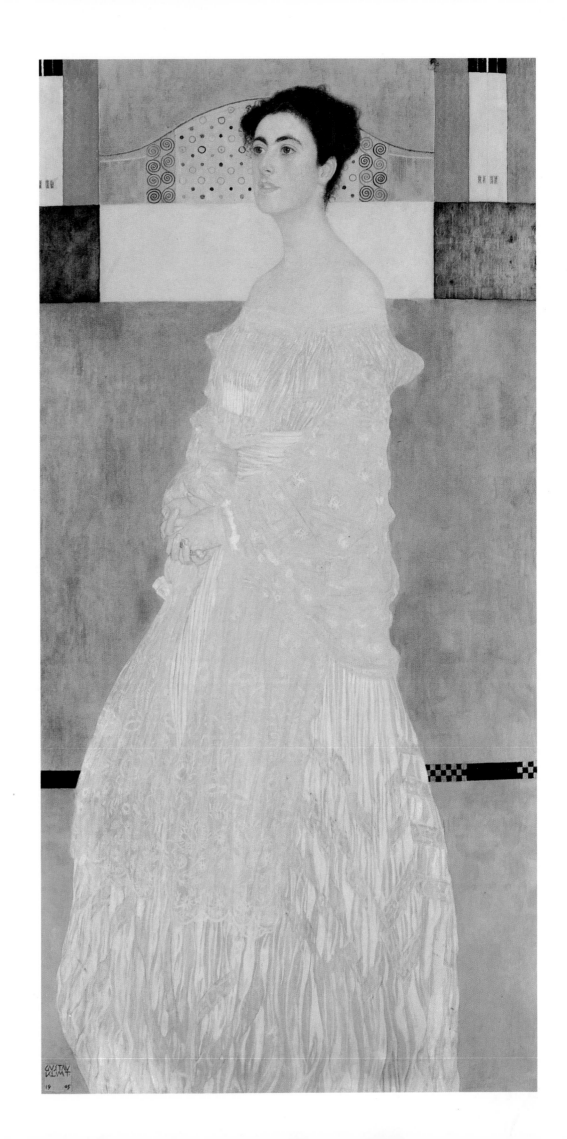

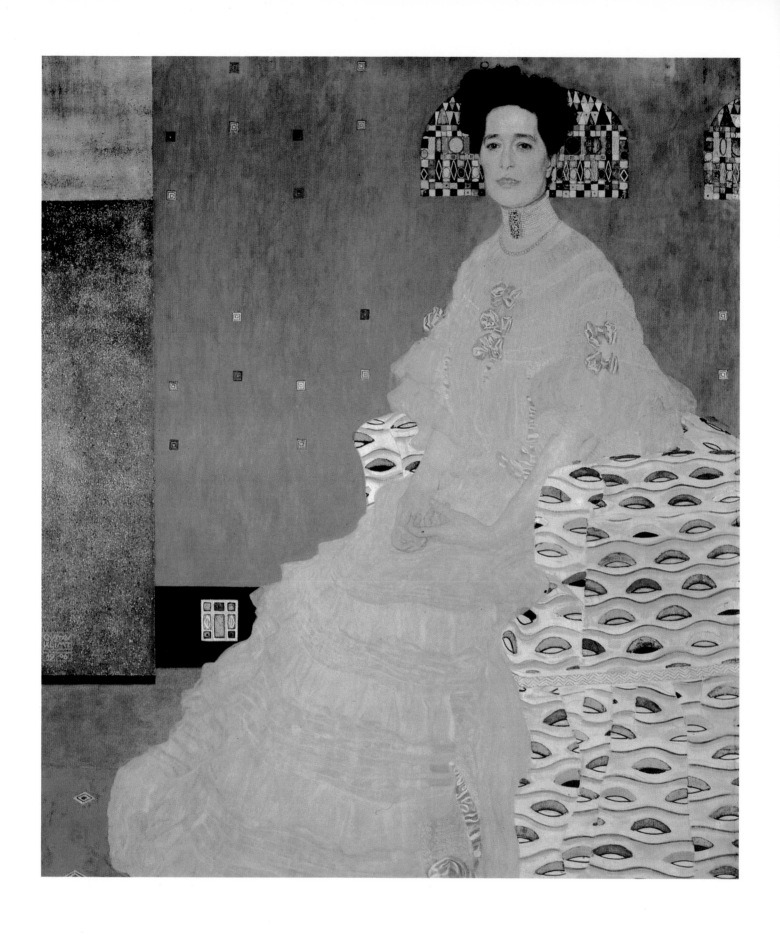

PORTRAIT OF FRITZA RIEDLER, 1906
Oil on canvas, 60¼ × 52⅜ inches (153 × 133 cm)
Österreichische Galerie, Vienna

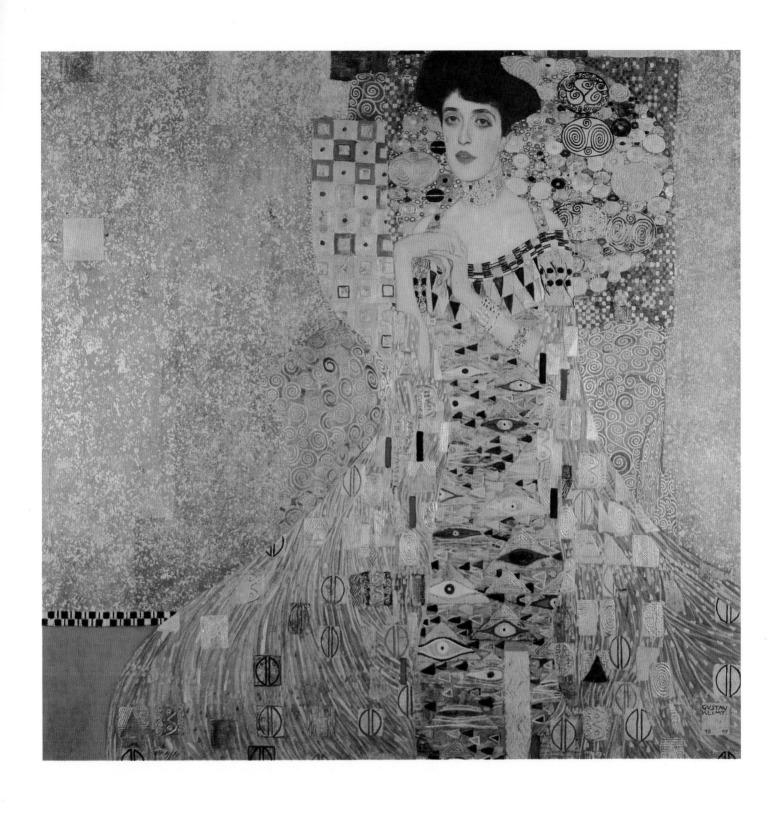

PORTRAIT OF ADÈLE BLOCH-BAUER I, 1907
Oil on canvas, 54⅓ × 54⅓ inches (138 × 138 cm)
Österreichische Galerie, Vienna

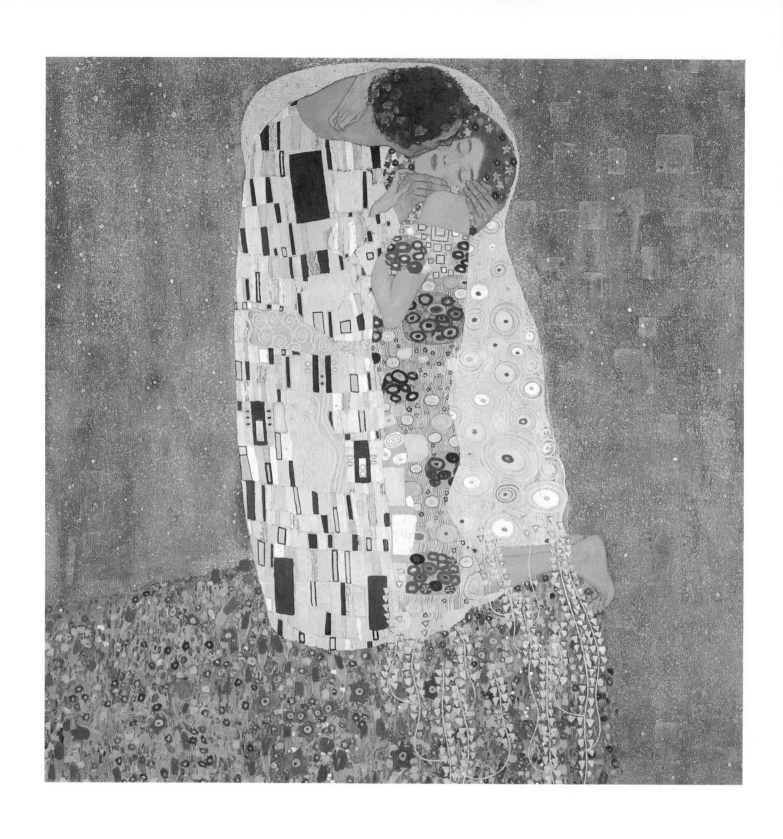

THE KISS, 1907-09
Oil on canvas, 70⅞ × 70⅞ inches (180 × 180 cm)
Österreichische Galerie, Vienna

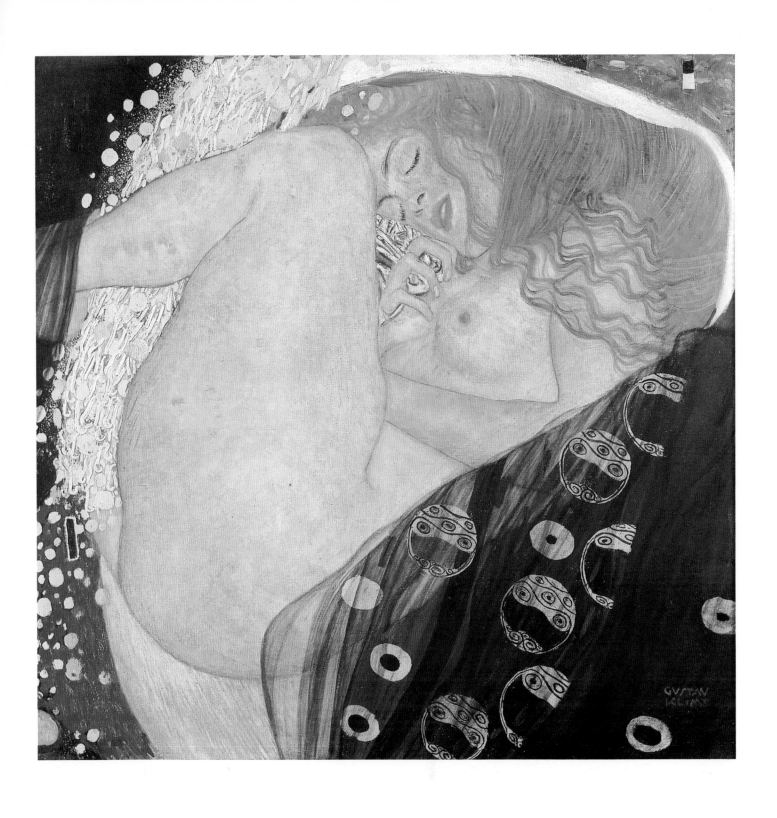

DANAË, *c.*1907-08
Oil on canvas, 30⅓ × 32⅝ inches (77 × 83 cm)
Private Collection

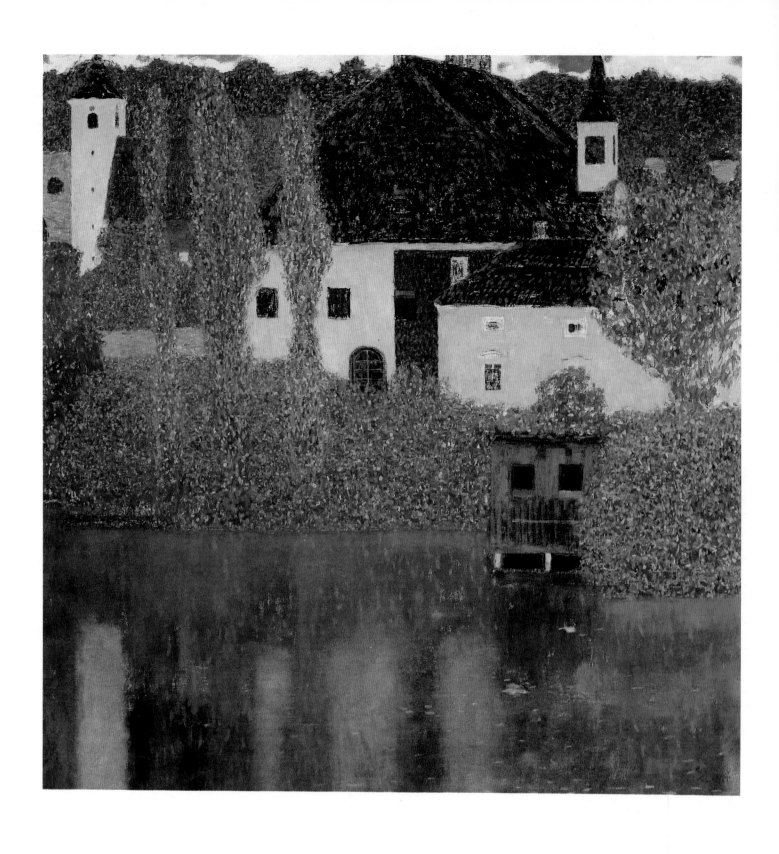

Above:
SCHLOSS KAMMER ON THE ATTERSEE I, *c.*1908
Oil on canvas, 43⅓ × 43⅓ inches (110 × 110 cm)
National Gallery, Prague

Right:
JUDITH II (SALOME), 1909
Oil on canvas, 70 × 18⅛ inches (178 × 46 cm)
Galleria d'Arte Moderna, Venice

30

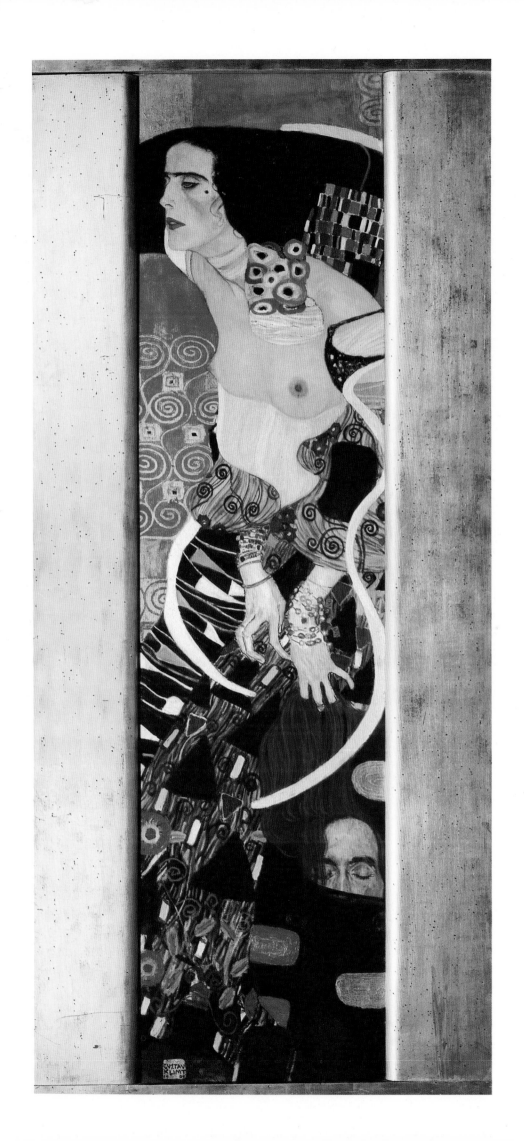

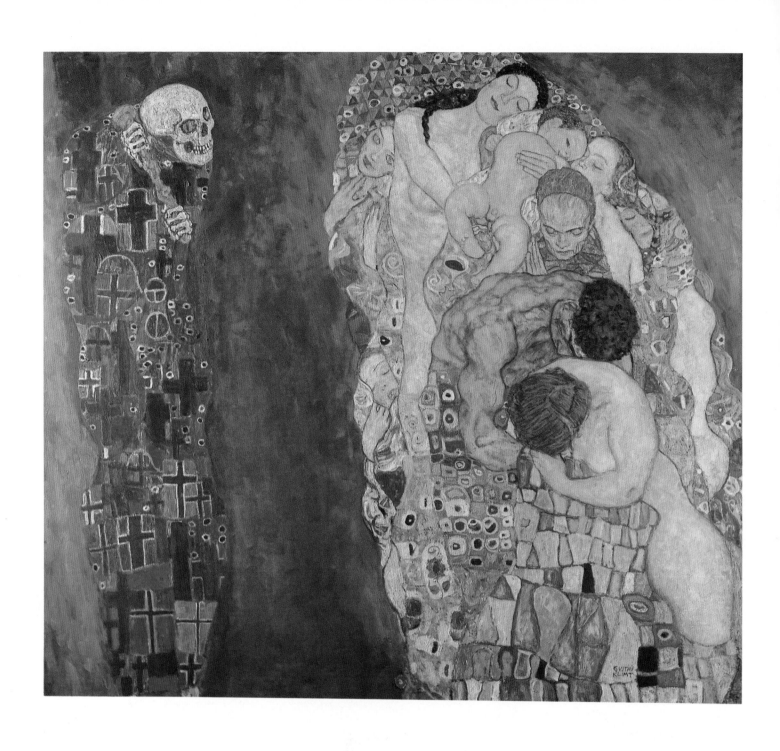

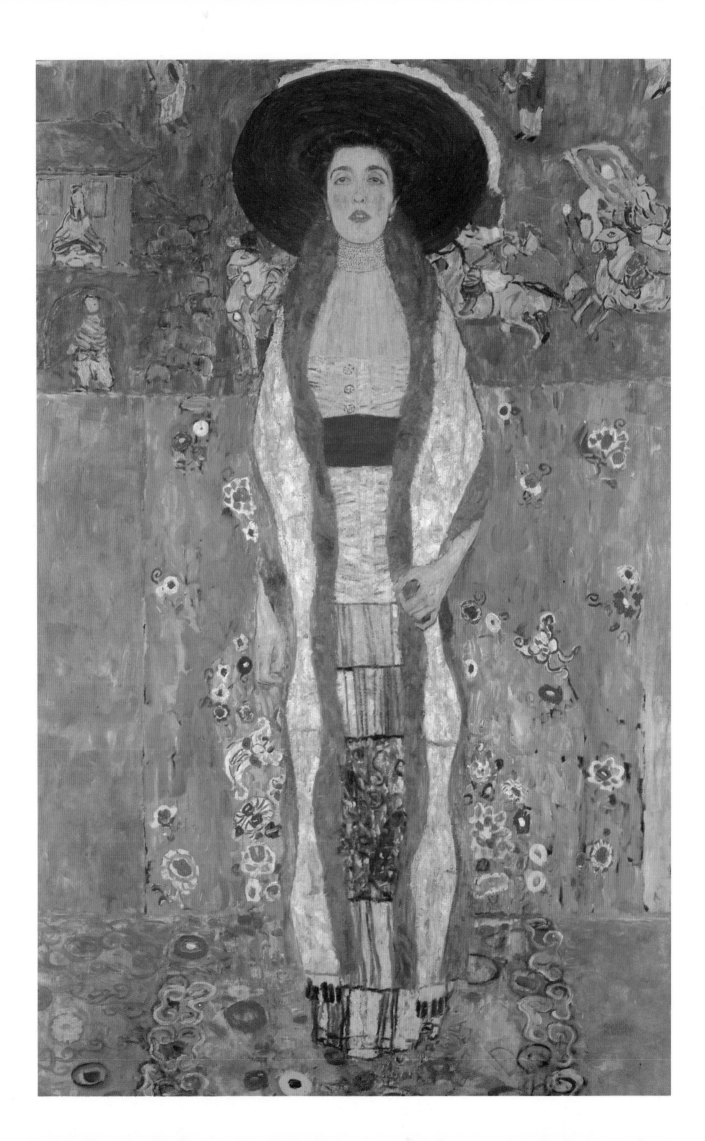

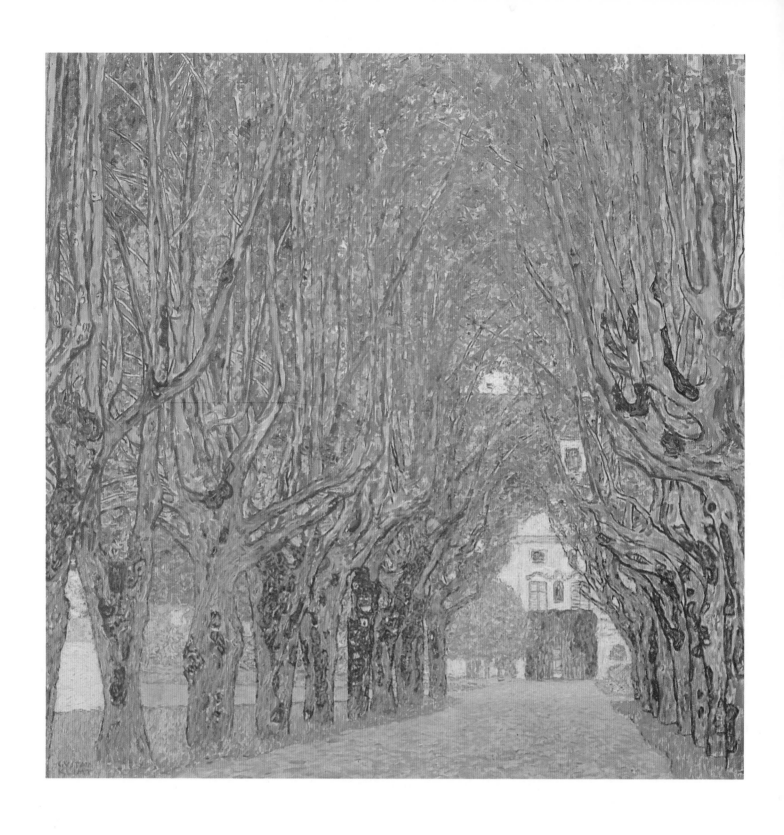

AVENUE IN THE PARK OF THE SCHLOSS KAMMER, 1912
Oil on canvas, 43⅓ × 43⅓ inches (110 × 110 cm)
Österreichische Galerie, Vienna

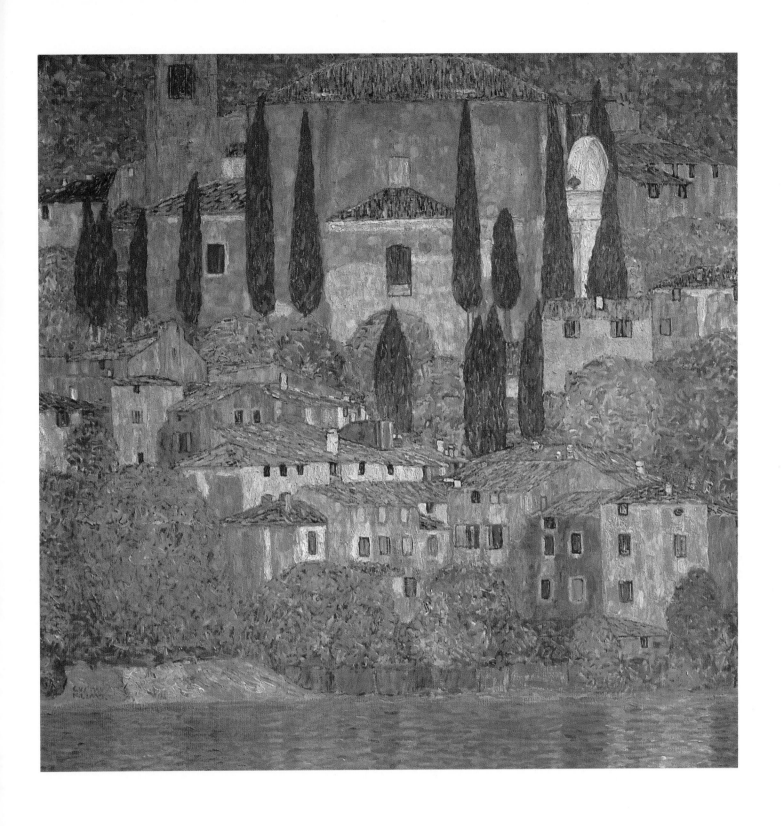

CHURCH AT CASSONE, 1913
Oil on canvas, 43⅓ × 43⅓ inches (110 × 110 cm)
Private Collection, Graz,
Courtesy Galerie Welz, Salzburg

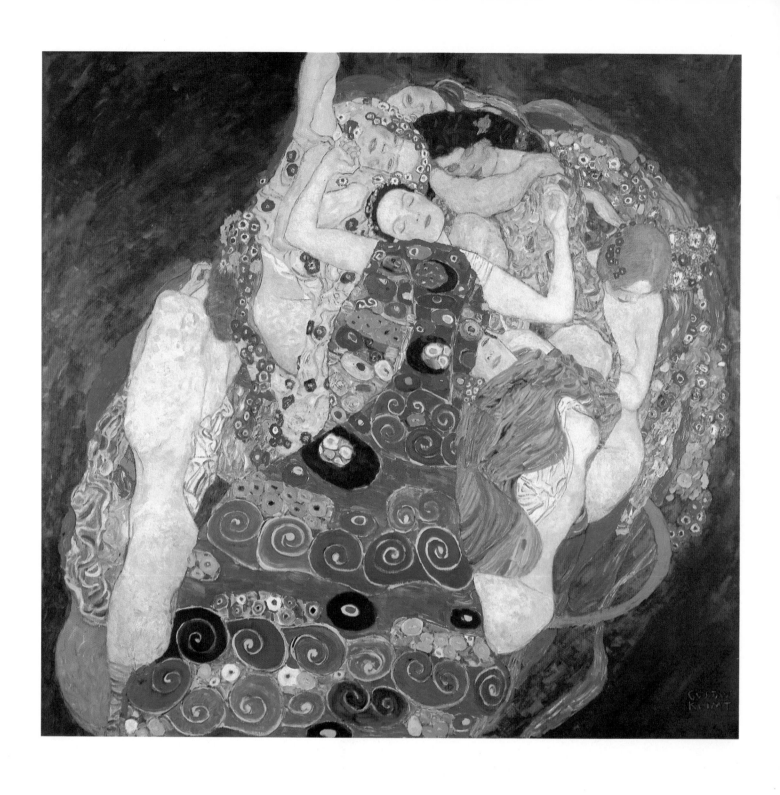

Above:
THE VIRGIN, 1913
Oil on canvas, 74⅞ × 78¾ inches (190 × 200 cm)
National Gallery, Prague

Right:
PORTRAIT OF BARONESS ELISABETH BACHOFEN-ECHT,
*c.*1914
Oil on canvas, 70⅞ × 50⅜ inches (180 × 128 cm)
Private Collection,
Courtesy Galerie Welz, Salzburg

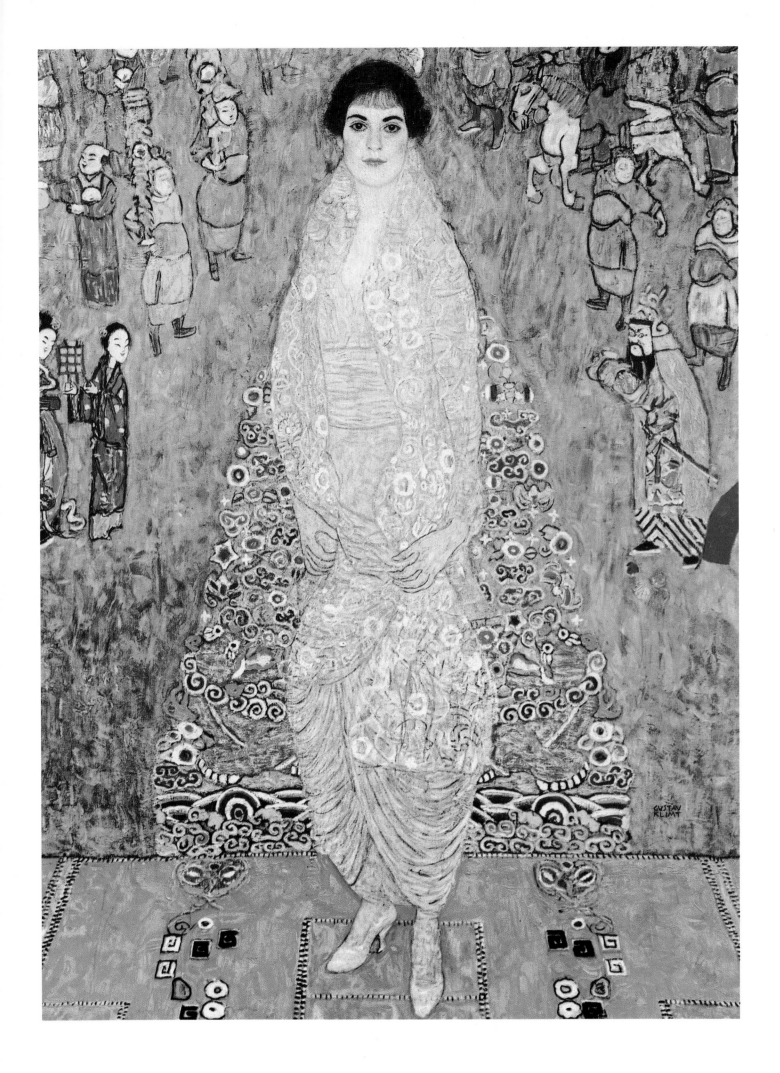

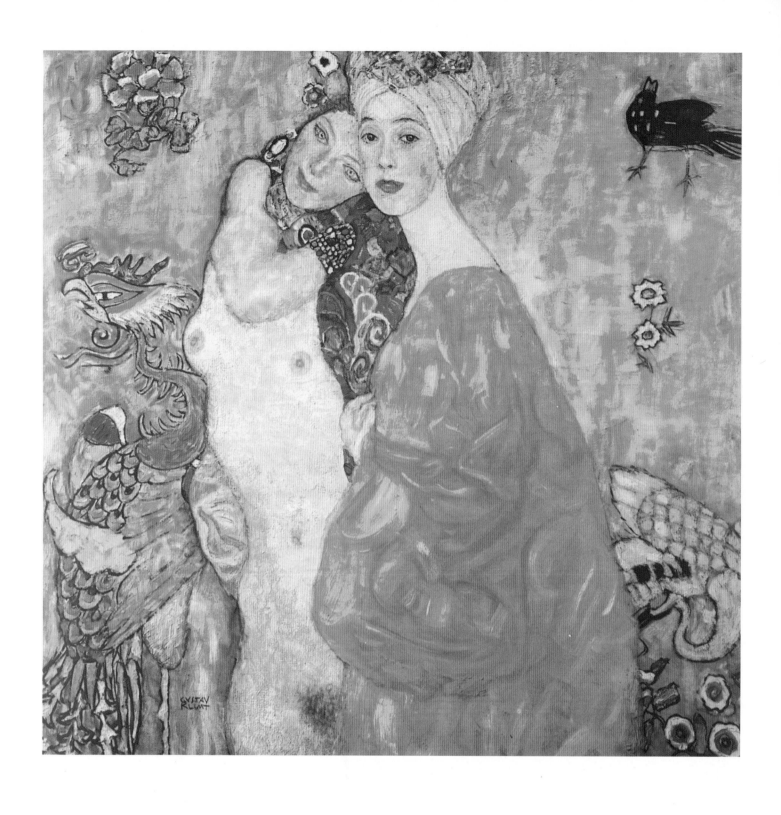

Above:
THE FRIENDS, 1916-17
Oil on canvas, 40 × 40(?) inches (99 × 99[?] cm)
Destroyed by fire, 1945

Right:
THE DANCER, *c.*1916-18
Oil on canvas, 70⅞ × 35⁷⁄₁₆ inches (180 × 90 cm)
Private Collection
Courtesy Galerie St. Etienne, New York

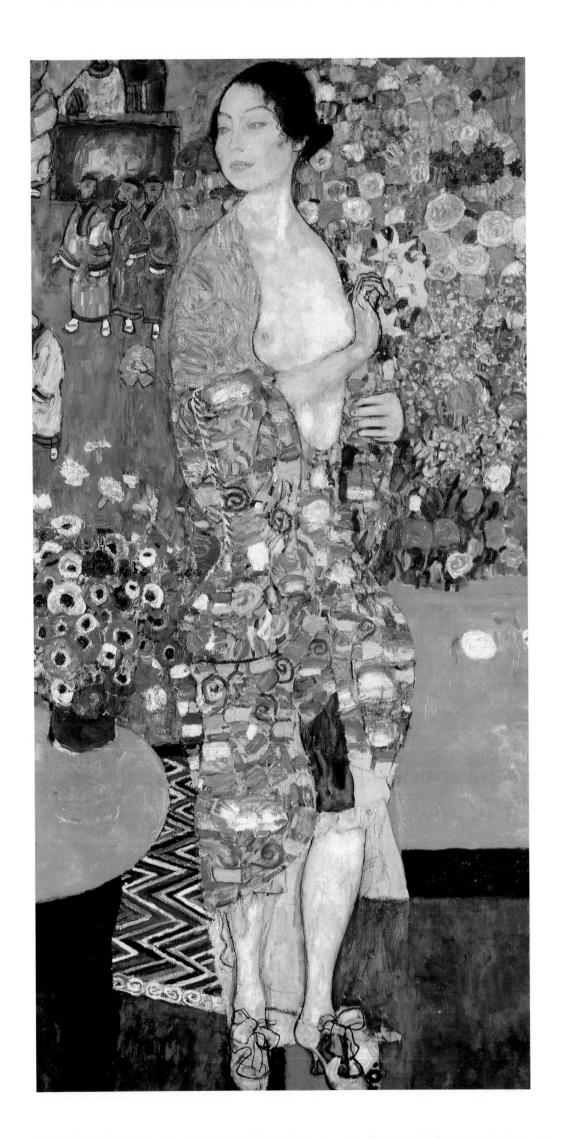

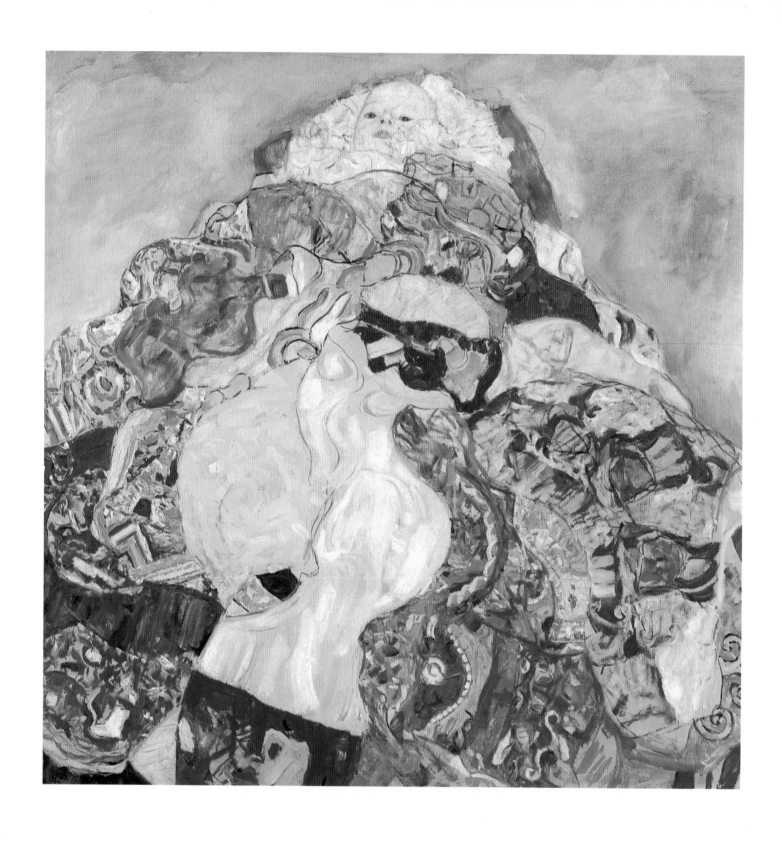

Above:
BABY, 1917-18
Oil on canvas, 43⅓ × 43⅓ inches (110 × 110 cm)
National Gallery of Art, Washington

Right:
ADAM AND EVE, 1917-18
Oil on canvas, 68⅛ × 23⅝ inches (173 × 60 cm)
Österreichische Galerie, Vienna

40

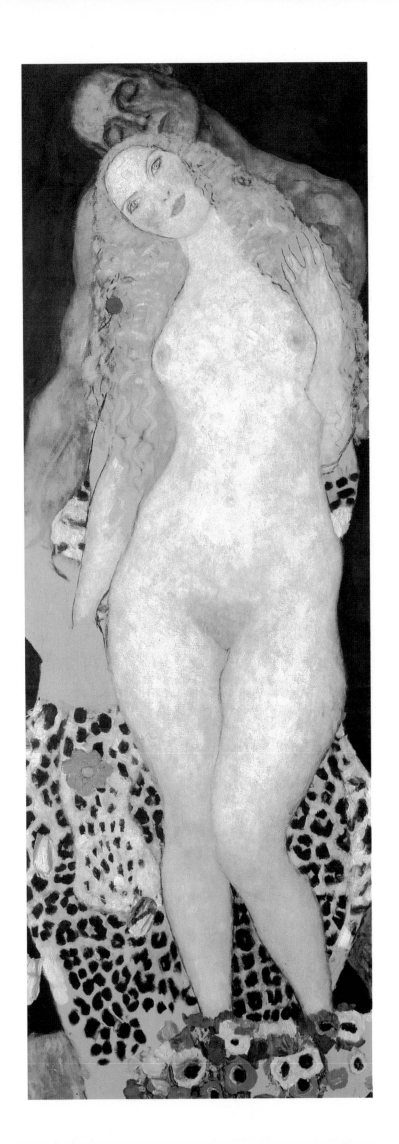

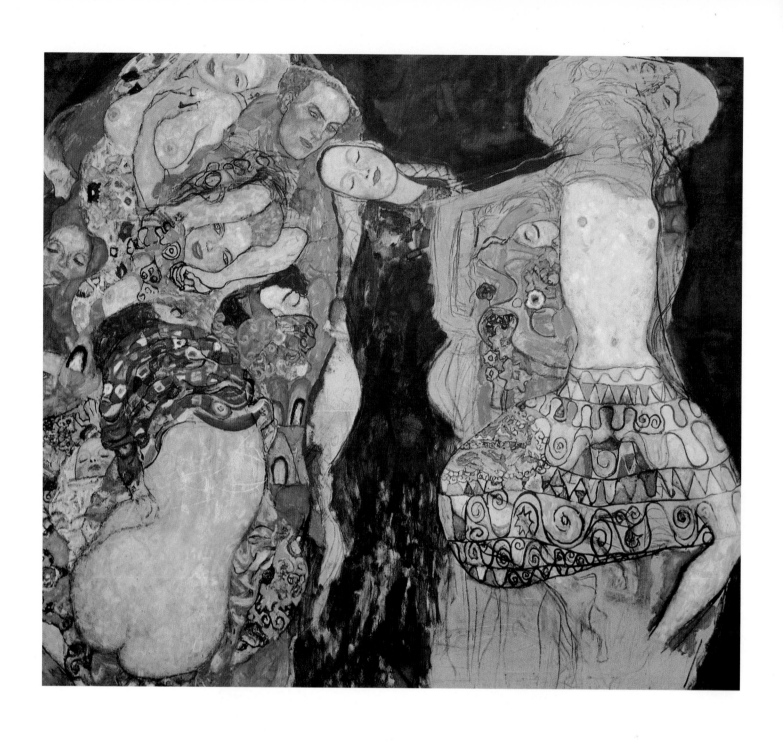

Above:
THE BRIDE, 1917-18 (unfinished)
Oil on canvas, 65⅜ × 74¾ inches (166 × 190 cm)
Private Collection

Right:
PORTRAIT OF A LADY, 1917-18
Oil on canvas, 70⅝ × 35³⁄₁₆ inches (180 × 90 cm)
Neue Galerie der Stadt Linz,
Wolfgang-Gurlitt-Museum

42

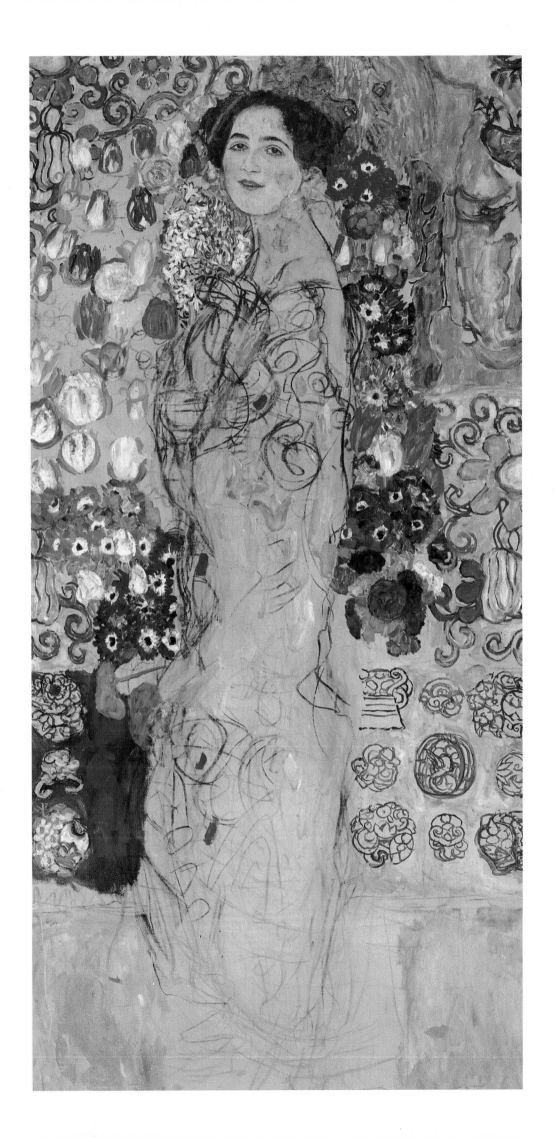

ACKNOWLEDGMENTS

The publisher wishes to thank Martin Bristow, who designed this book; Veronica Price and Nicki Giles for production; and Clare Haworth-Maden, the editor. The following agencies and individuals supplied the illustrations:

Bayerische Staatsgemäldesammlungen, Neue Pinakothek, Munich: pages 10-11, 25

Galleria d'Arte Moderna, Venice: page 31

Galleria Nazionale d'Arte Moderna, Rome: page 22

Historisches Museum der Stadt Wien, Vienna: pages 12, 14

Collection Dr. Rudolf Leopold, Vienna: page 32

Moderne Galerie, Dresden: page 21

National Gallery, Prague: pages 30, 36

National Gallery of Art, Washington: page 40

Neue Galerie der Stadt Linz, Wolfgang-Gurlitt-Museum: page 43

Österreichische Galerie, Vienna: pages 8-9, 13, 15, 20, 24, 26, 27, 28, 33, 34, 41

Österreichische Galerie, Vienna/FOTOSTUDIO OTTO: page 38

Österreichisches Museum für Angewandte Kunst, Vienna: page 23

Private Collection: pages 29, 42

Private Collection, Courtesy Galerie St. Etienne, New York: pages 18, 39

Private Collection, Courtesy Galerie Welz, Salzburg: page 37

Private Collection, Graz, Courtesy Galerie Welz, Salzburg: page 35

Private Collection, Solothurn, Courtesy Galerie Welz, Salzburg: page 19